How to Draw
Faces

In Simple Steps

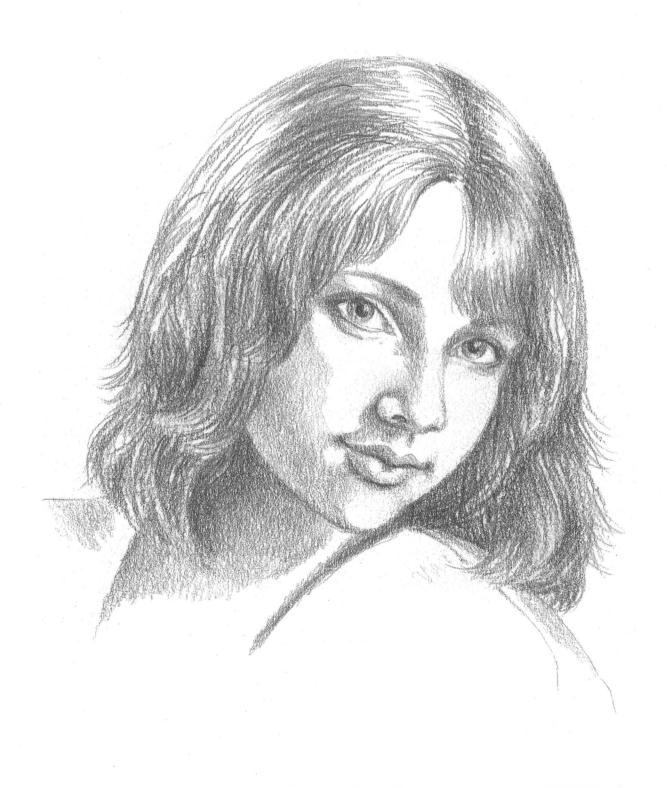

First published in Great Britain 2011

Search Press Limited
Wellwood, North Farm Road,
Tunbridge Wells, Kent TN2 3DR

Reprinted 2012, 2013, 2014, 2015 (twice)

Text copyright © Susie Hodge 2011

Design and illustrations copyright © Search Press Ltd. 2011

ISBN: 978-1-84448-673-1

Printed in Malaysia

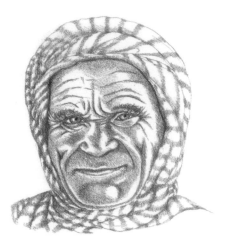

Dedication

*This book is dedicated to my two gorgeous
children, Katie and Jonathan*

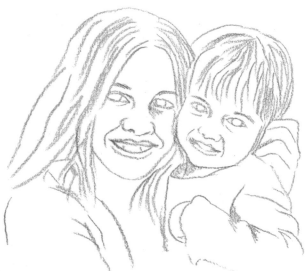

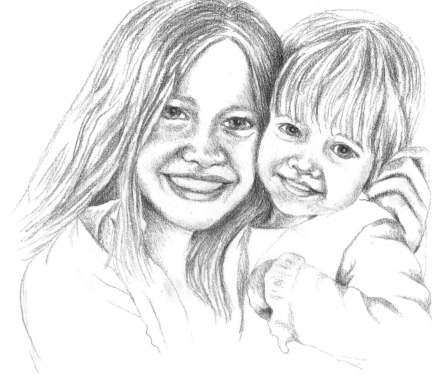

How to Draw
Faces
In Simple Steps

Susie Hodge

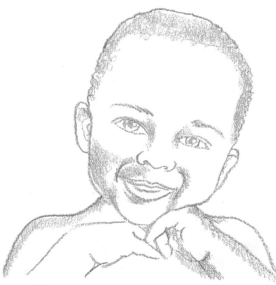

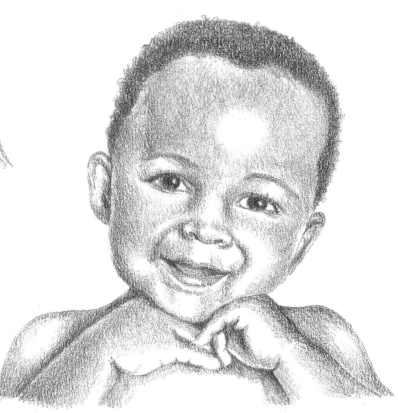

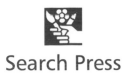

Search Press

Introduction

Capturing the likeness of a person's face is often perceived as something that only a few artists can do, but this book shows you how with patience, anyone can draw faces successfully. The following pages feature twenty-eight head-to-shoulder portraits of people of various ages, sexes and nationalities, giving you a broad variety to try out.

The likenesses are each shown in a step-by-step sequence. At the first stage, in green pencil, the head and shoulders are drawn as simple shapes, with guidelines marking the placement of the features. At the second and third stages, the previous marks become blue, while green is used to build the picture, focusing on angles and proportions. At stage four, the green pencil is used to add tone and some details such as nostrils and eyebrows. The fifth stage is drawn in graphite pencil and further developed into a finished drawing, showing you where to add soft or deep tones, texture, and more details such as eyes and hair. Finally, the sitter's face is painted in natural colours, showing another method you might like to try.

When following the stages, use a sharp B or 2B pencil. Draw lightly, so that any initial guidelines can be erased easily. Keep objective and notice the shapes around, and distances between features. When you feel more confident about your drawing, try working in colour, perhaps with coloured pencils, pastels, acrylics, gouache or, as I have done, in watercolour.

The faces featured all vary, but follow the process of drawing simple shapes and lines in the first steps and then building up the features with shading. Notice that all heads, with some modifications, are almost egg-shaped. Look to see where the darkest tones fall. See which aspects of the face are indicated by tonal shading, and which with firm lines.

I hope you will draw all the faces in this book and then go on to draw your own friends' and family's likenesses, using the simple construction method I have shown. You will soon grow in confidence and your portraits will become even more accomplished.

Happy drawing!

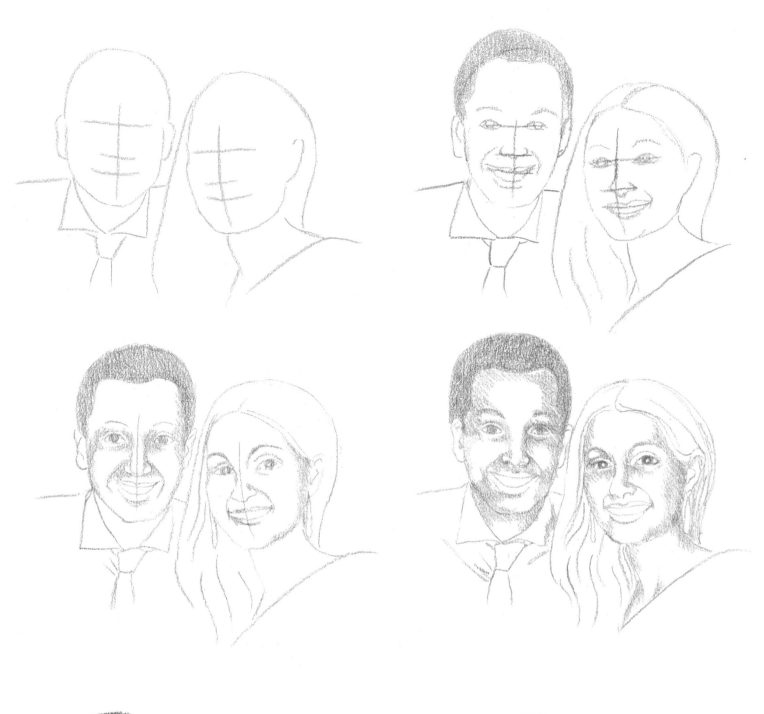
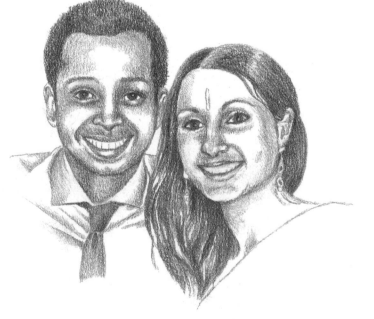
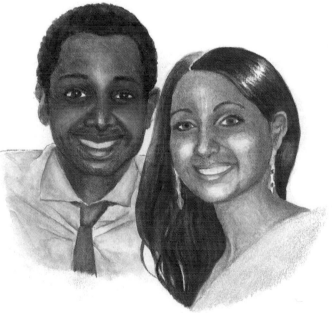

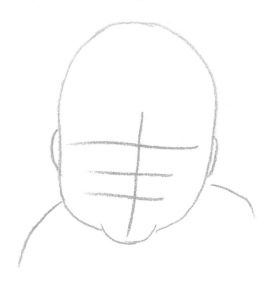

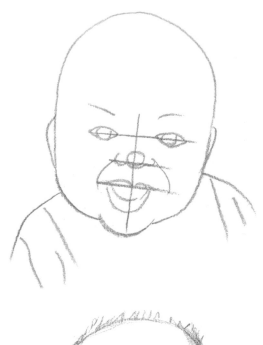

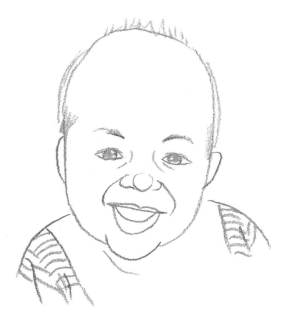

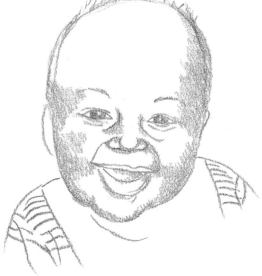

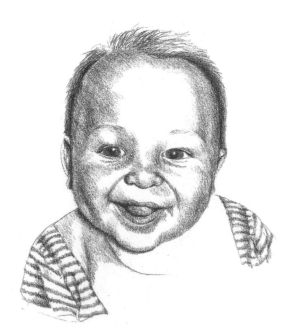

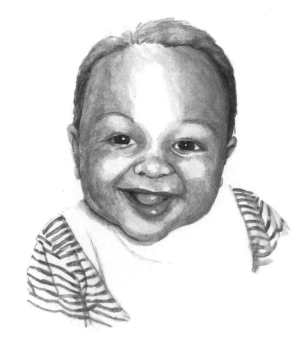

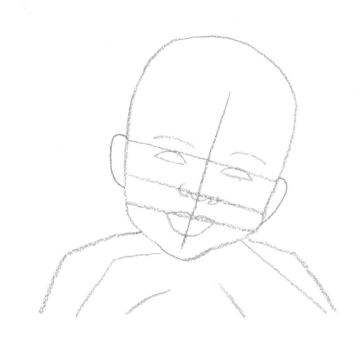

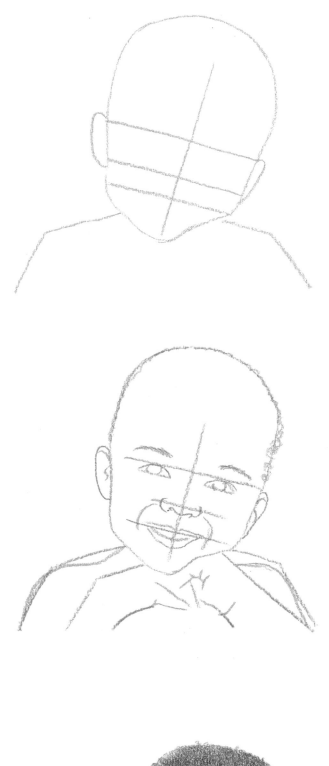

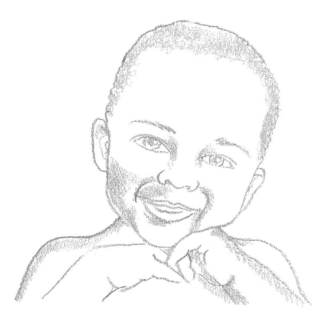

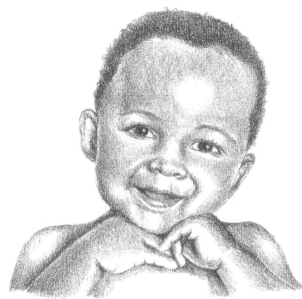

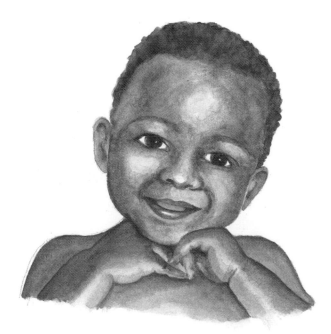

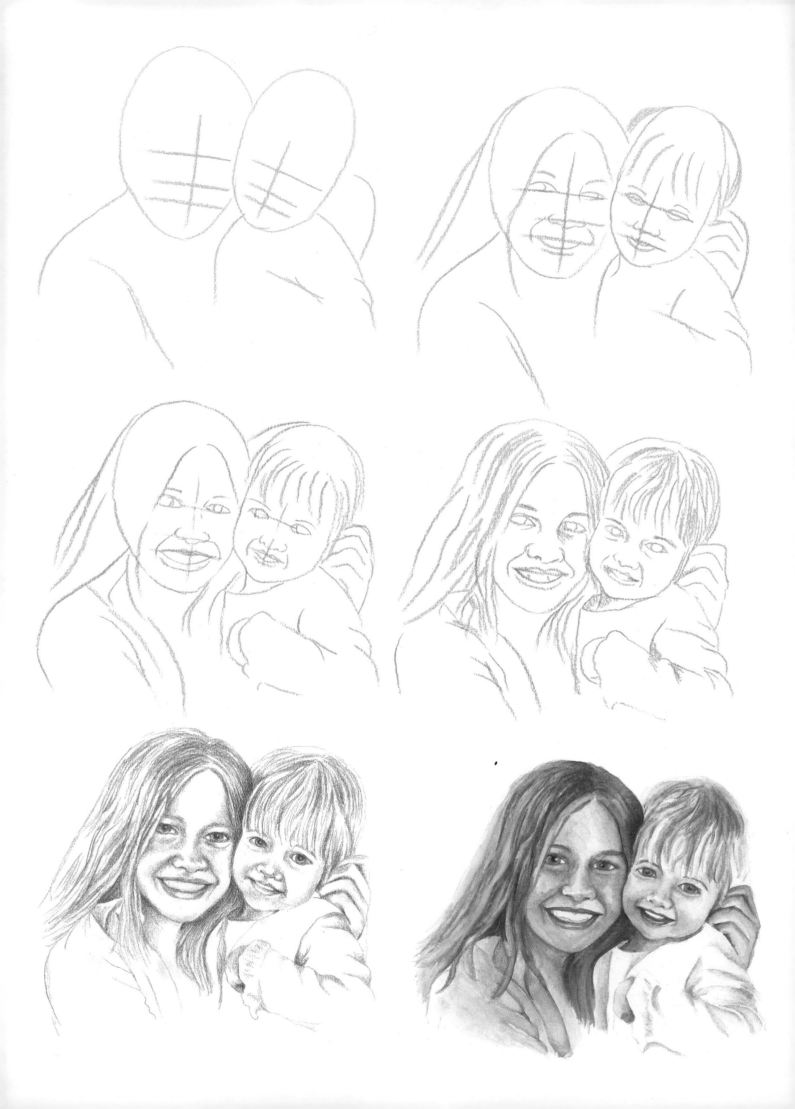

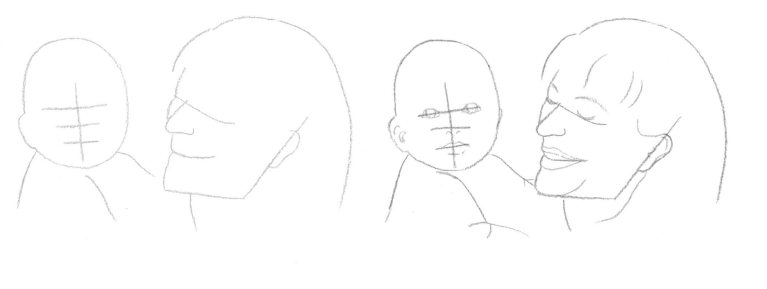

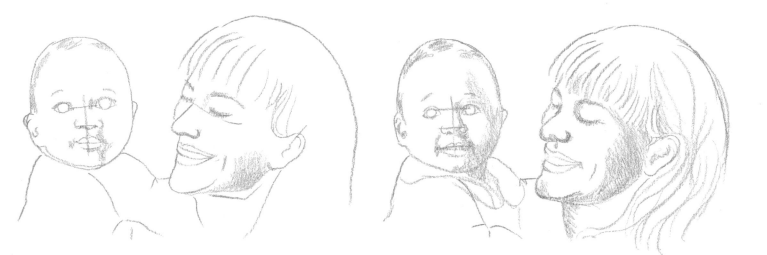

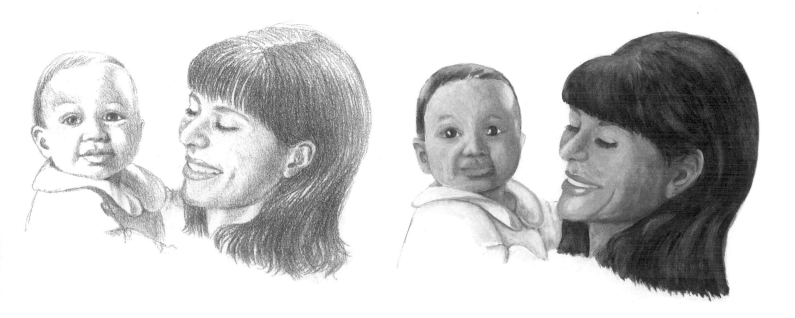

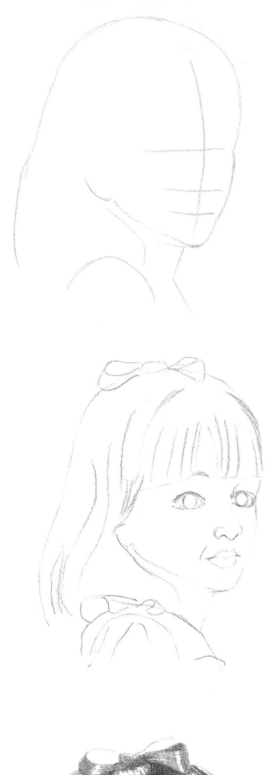
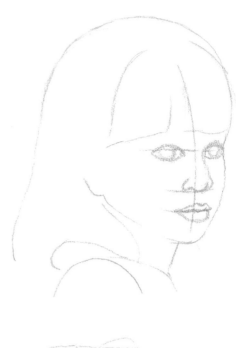
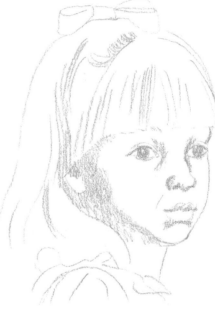
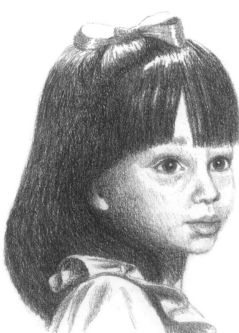
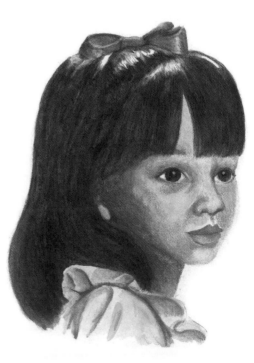

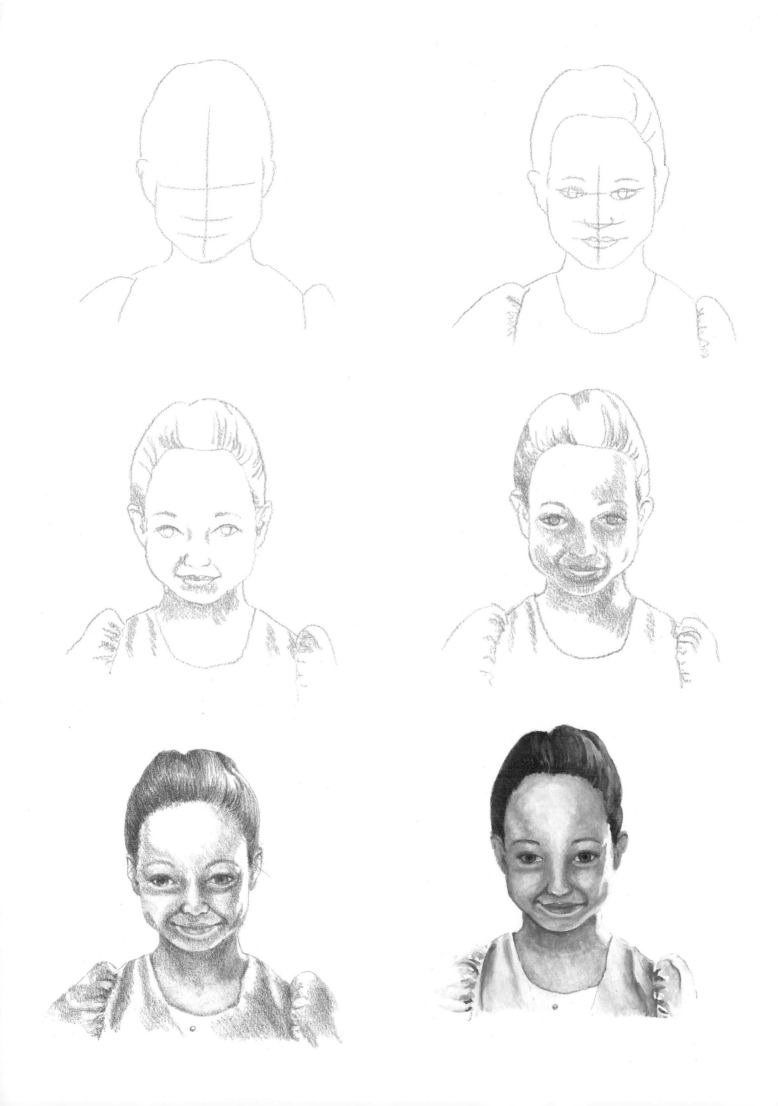

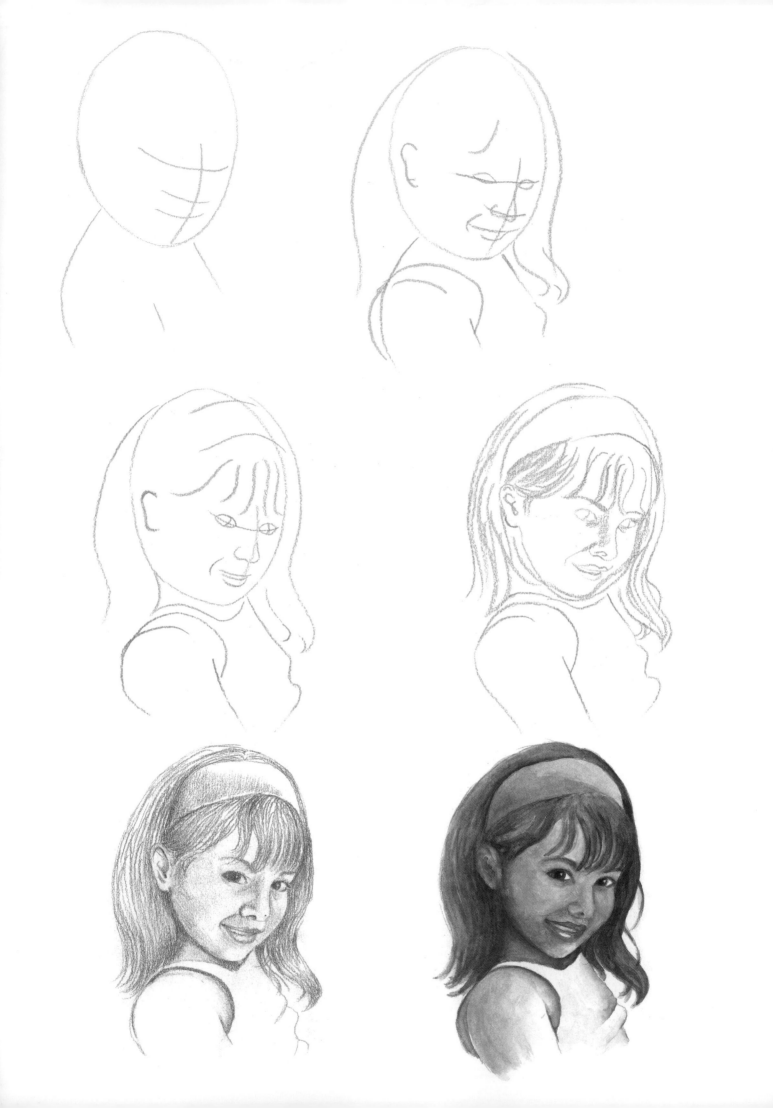

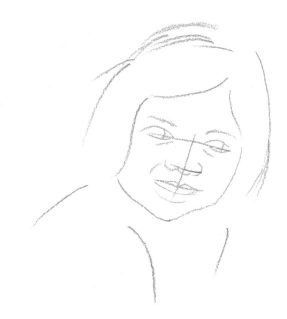

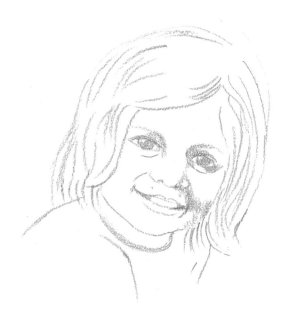

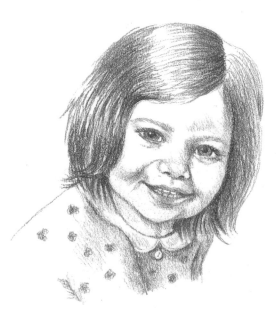

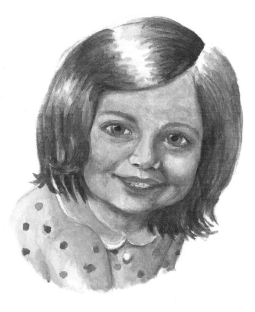

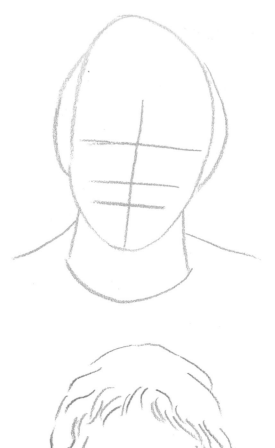
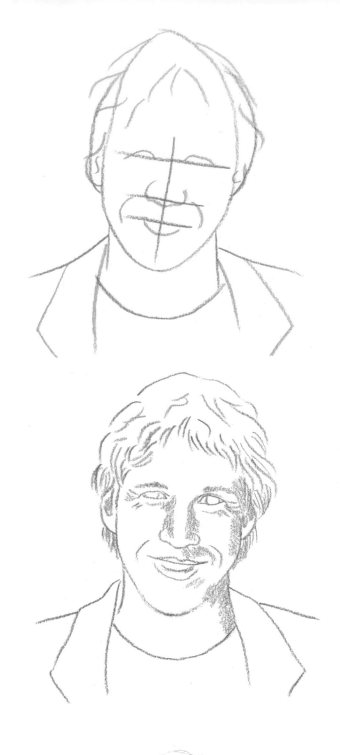
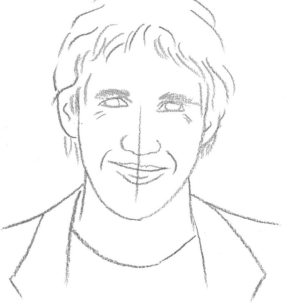
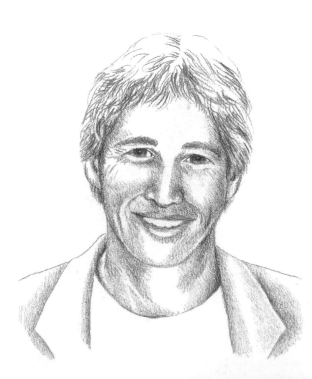
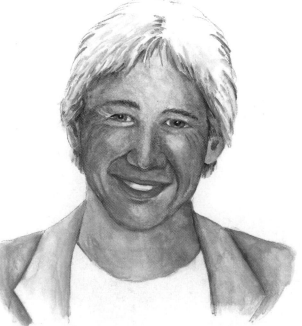

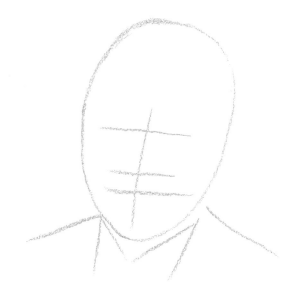
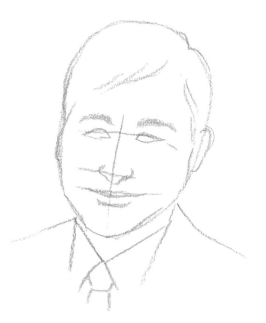
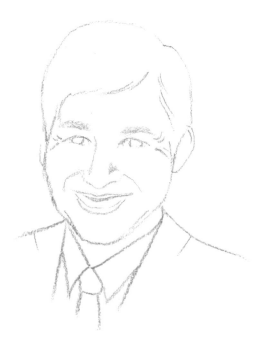
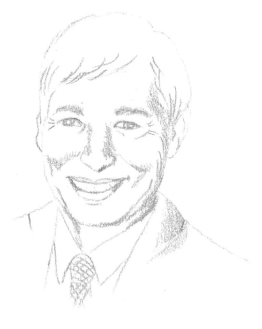
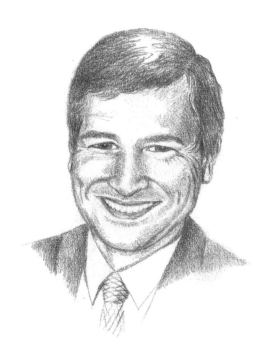
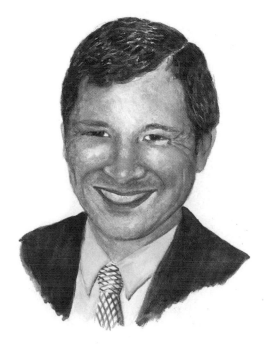

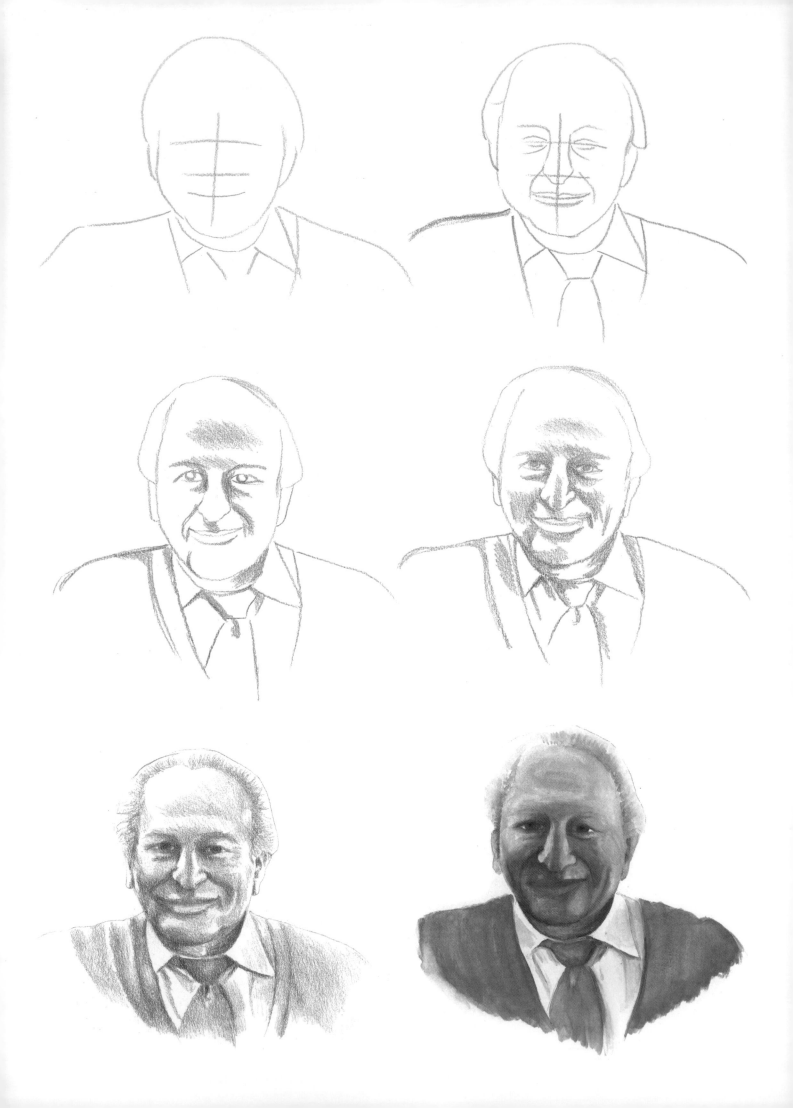

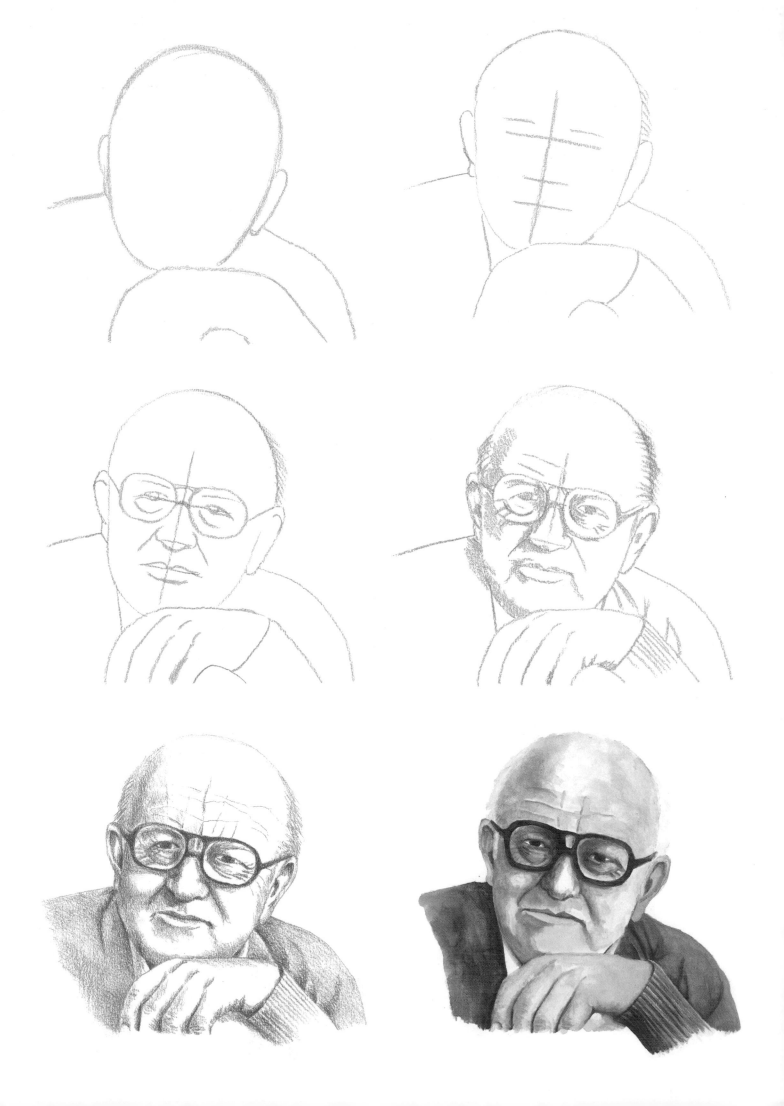

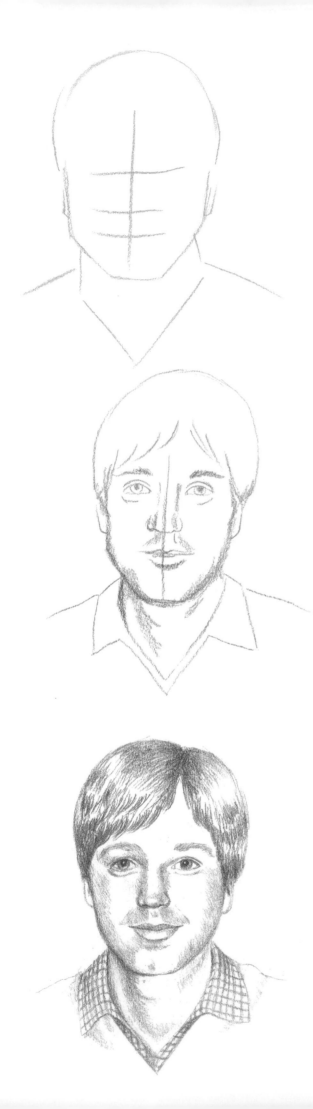
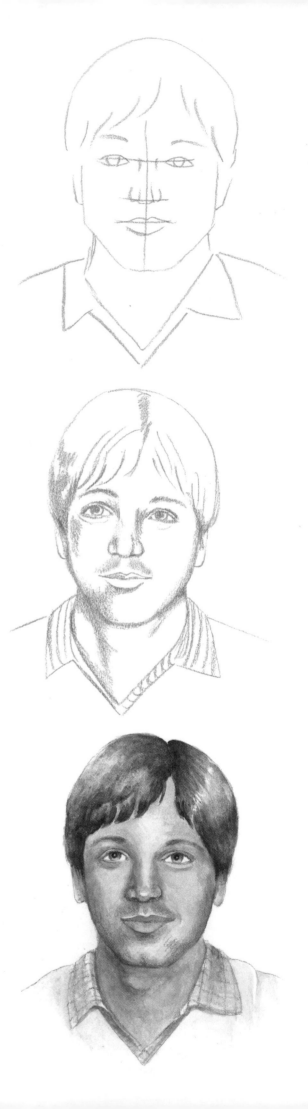

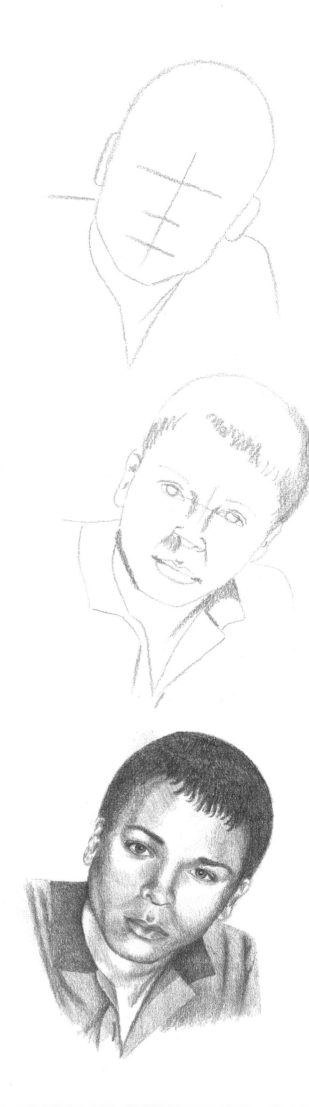
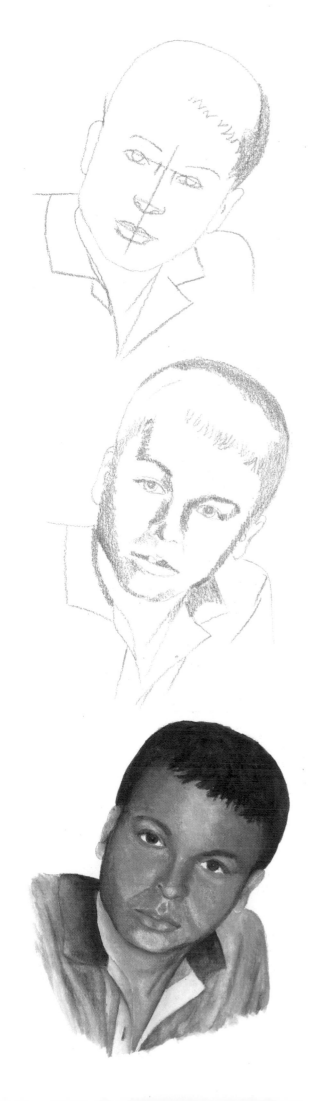

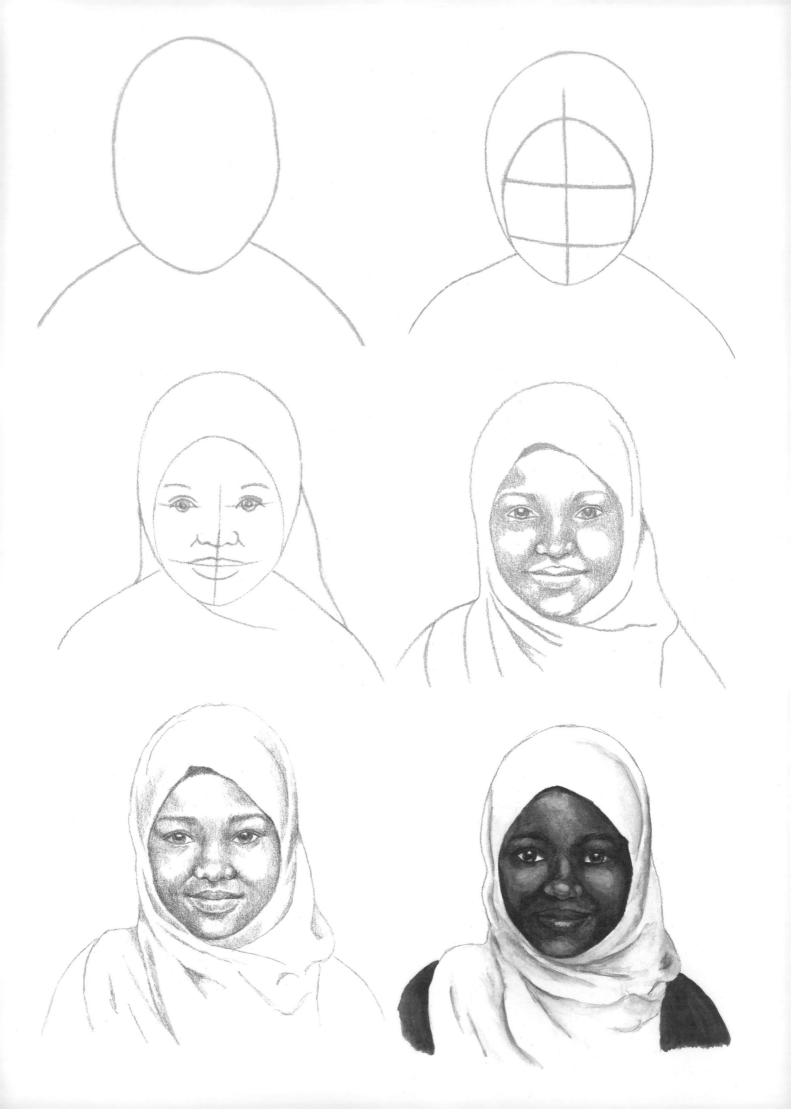

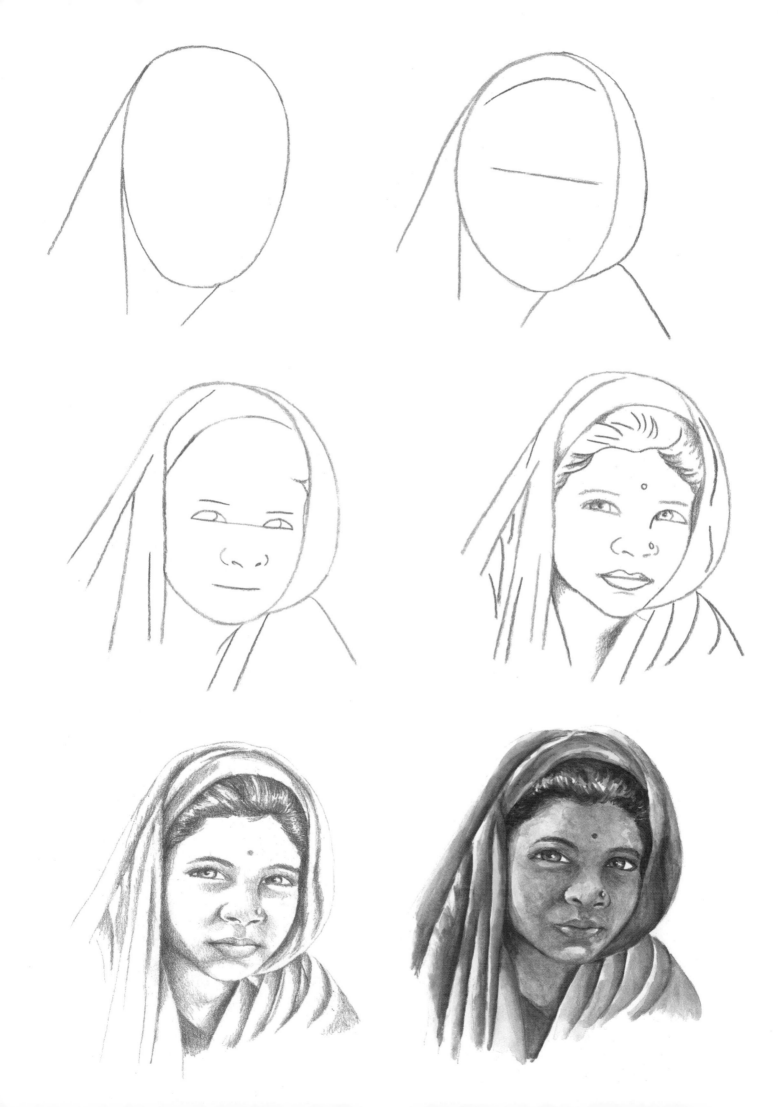

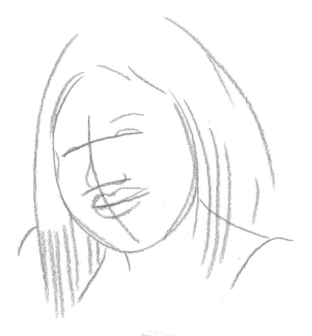

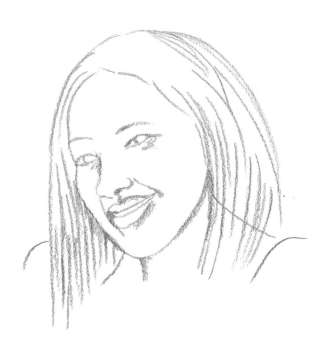

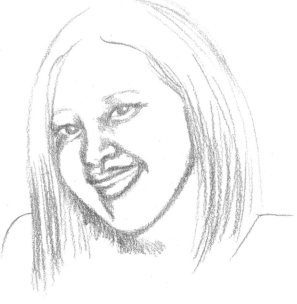

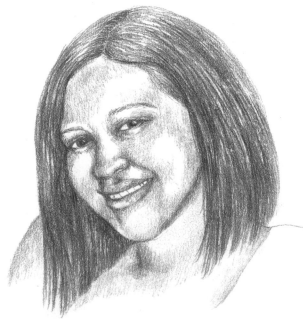

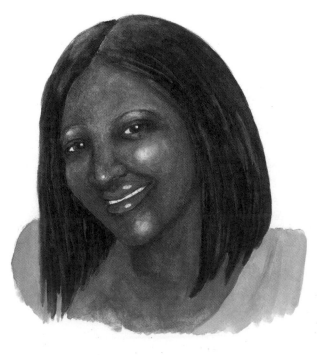

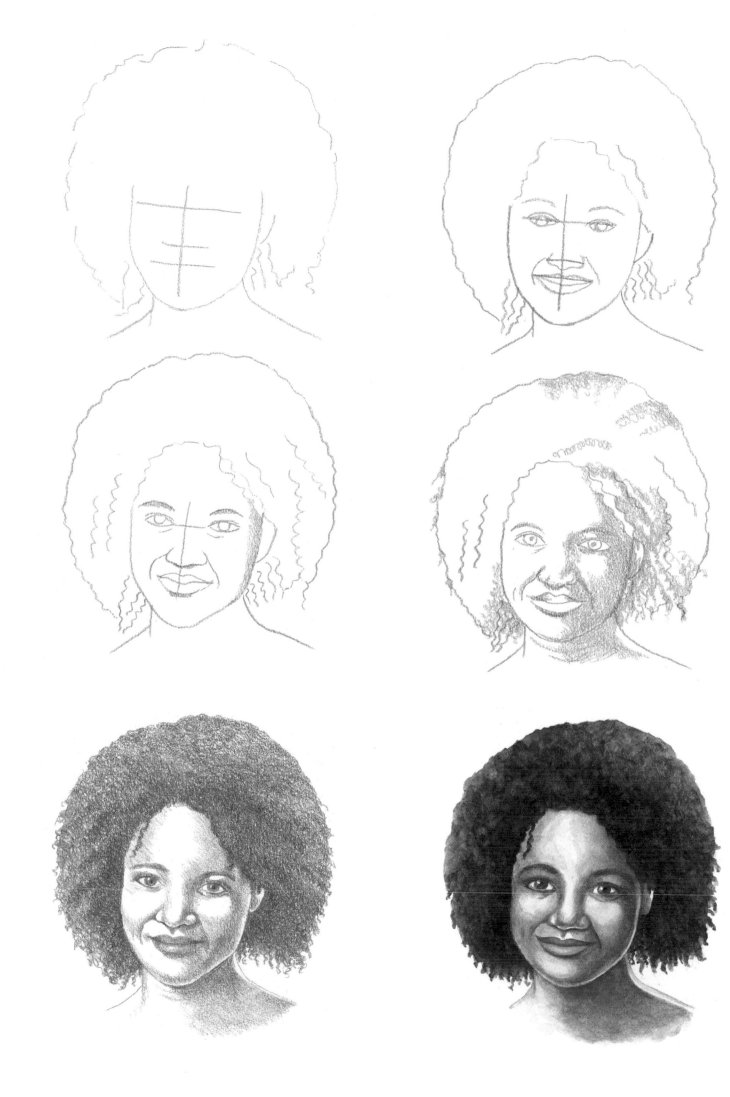

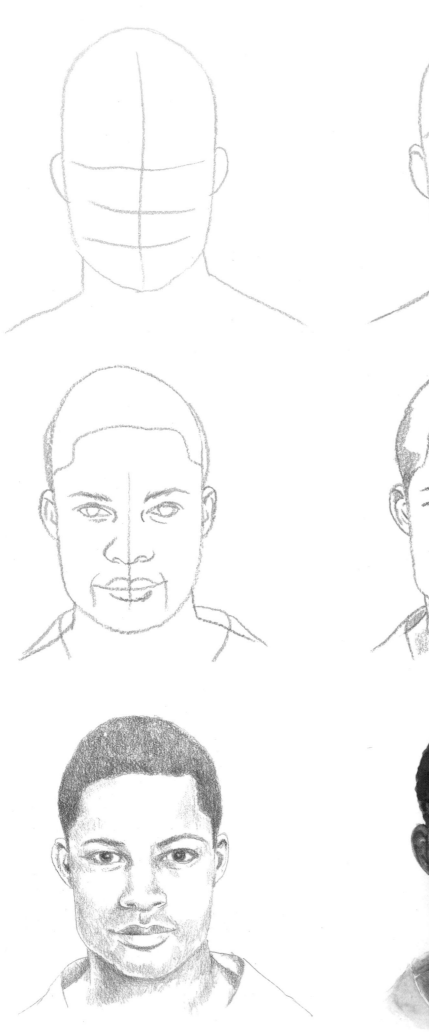
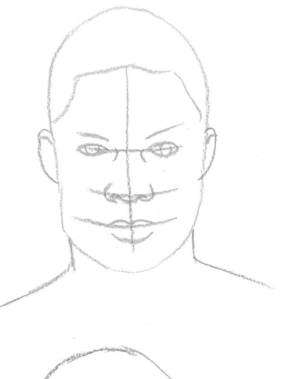
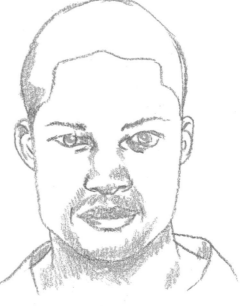
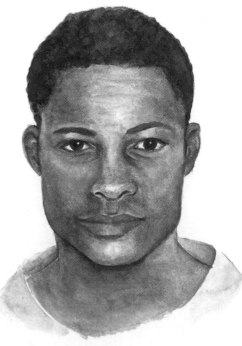

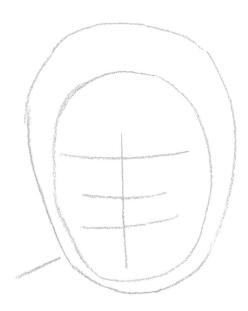
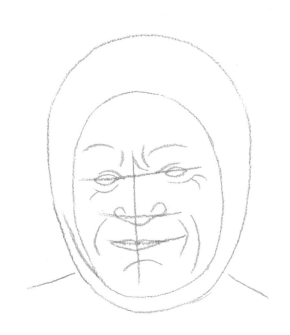
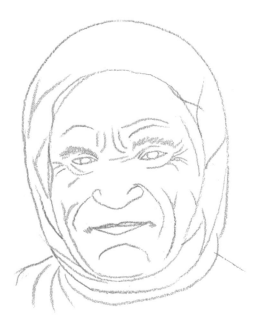
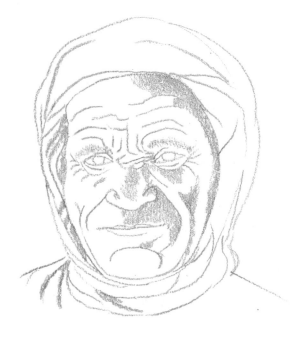
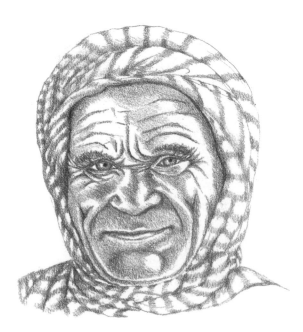
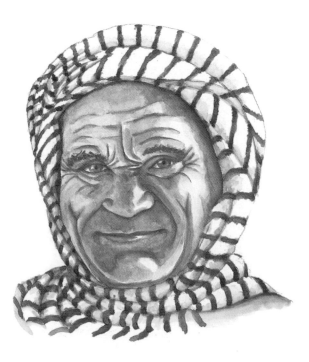

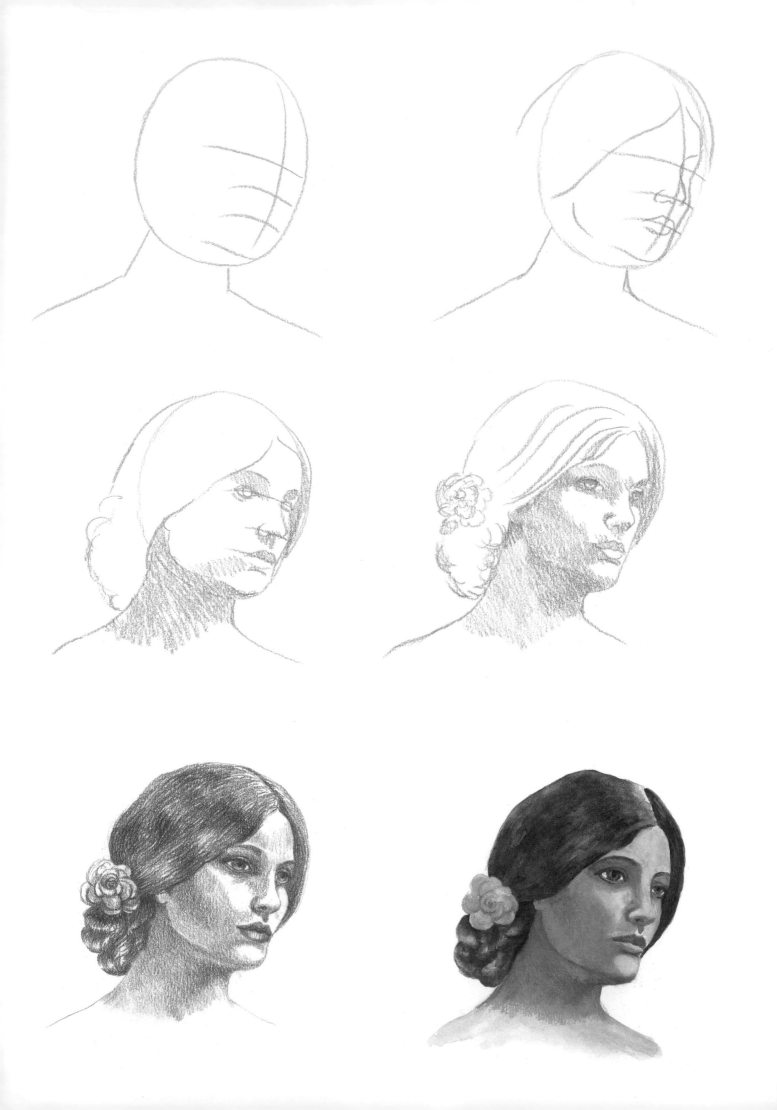

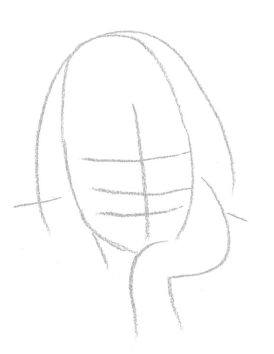
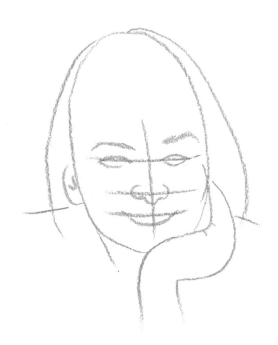
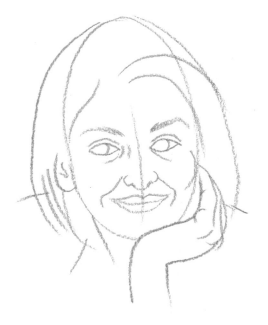
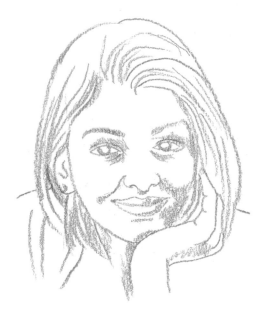
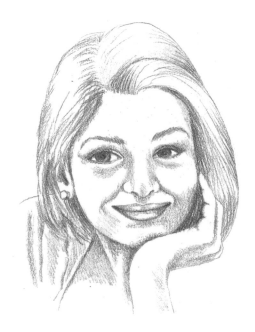
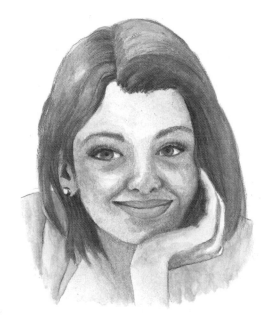

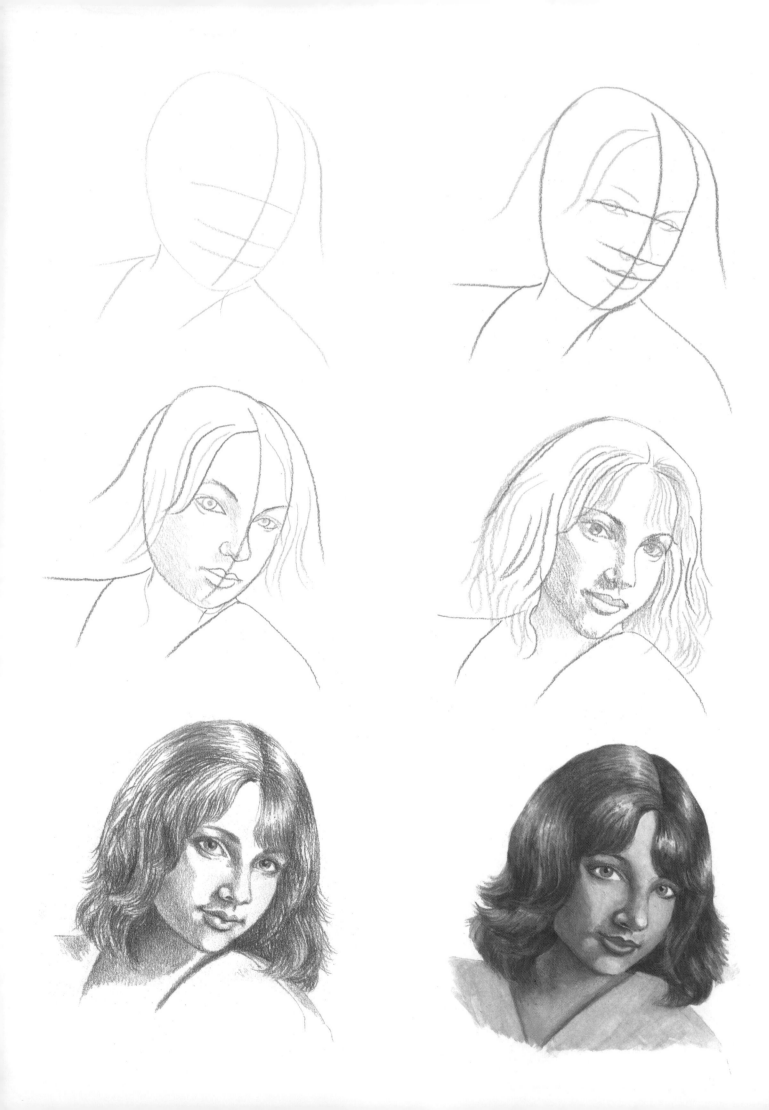

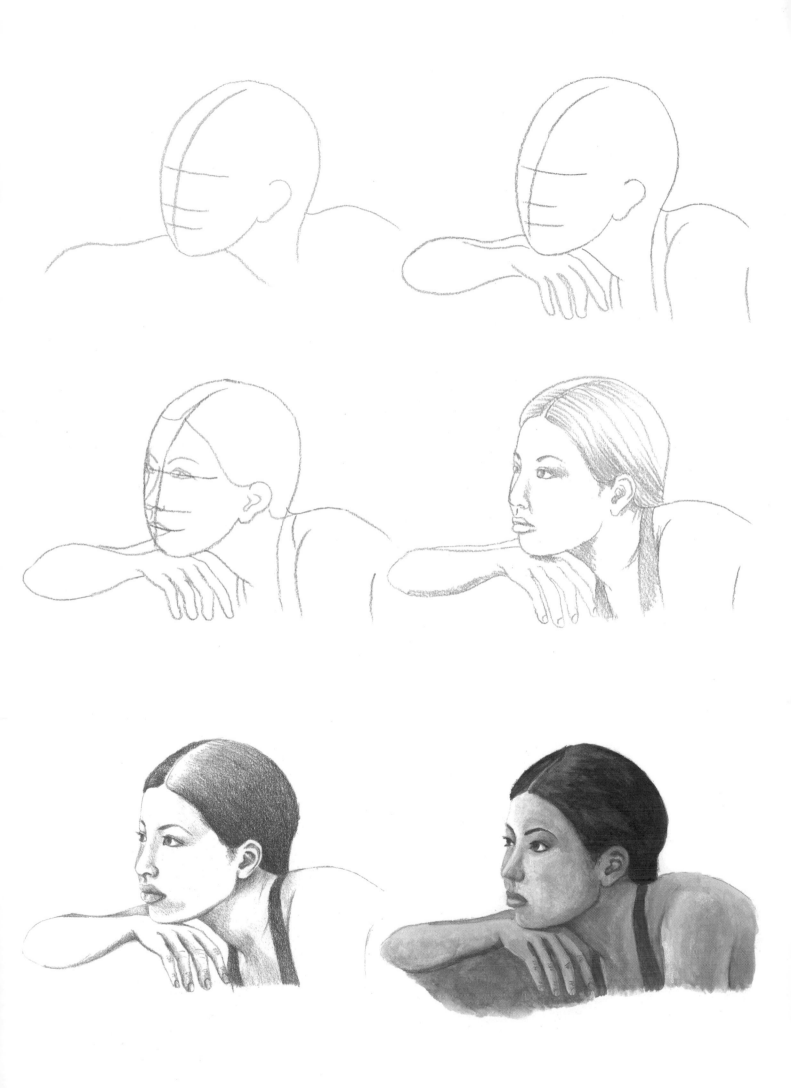

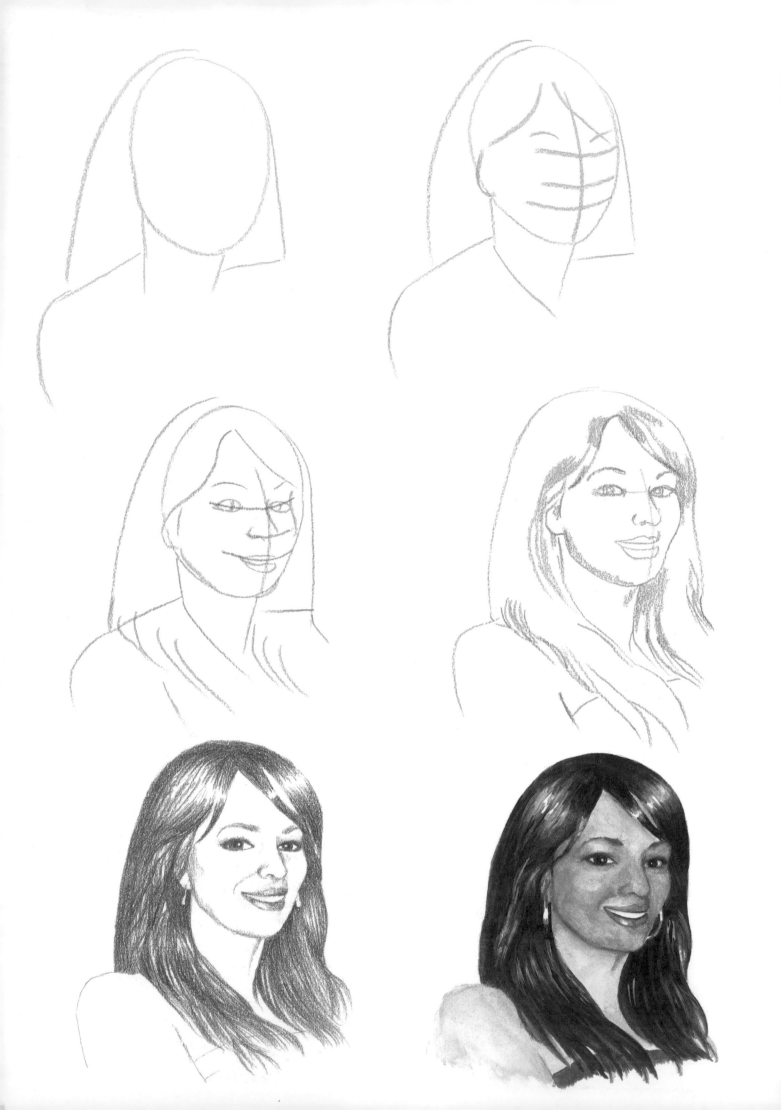

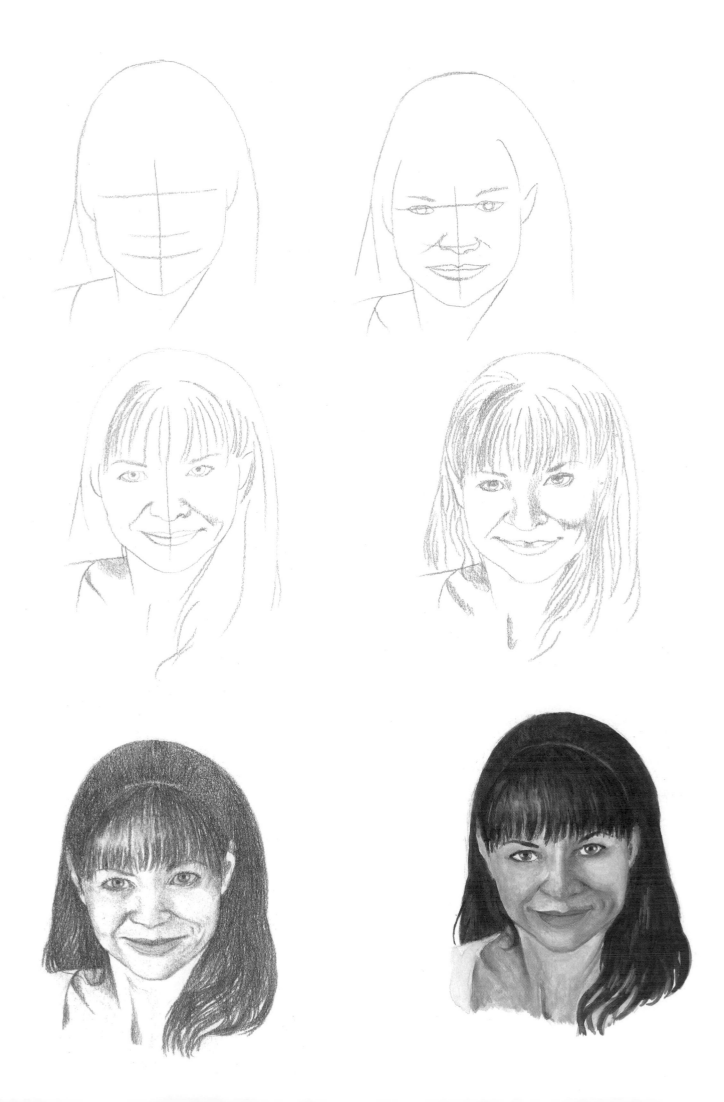

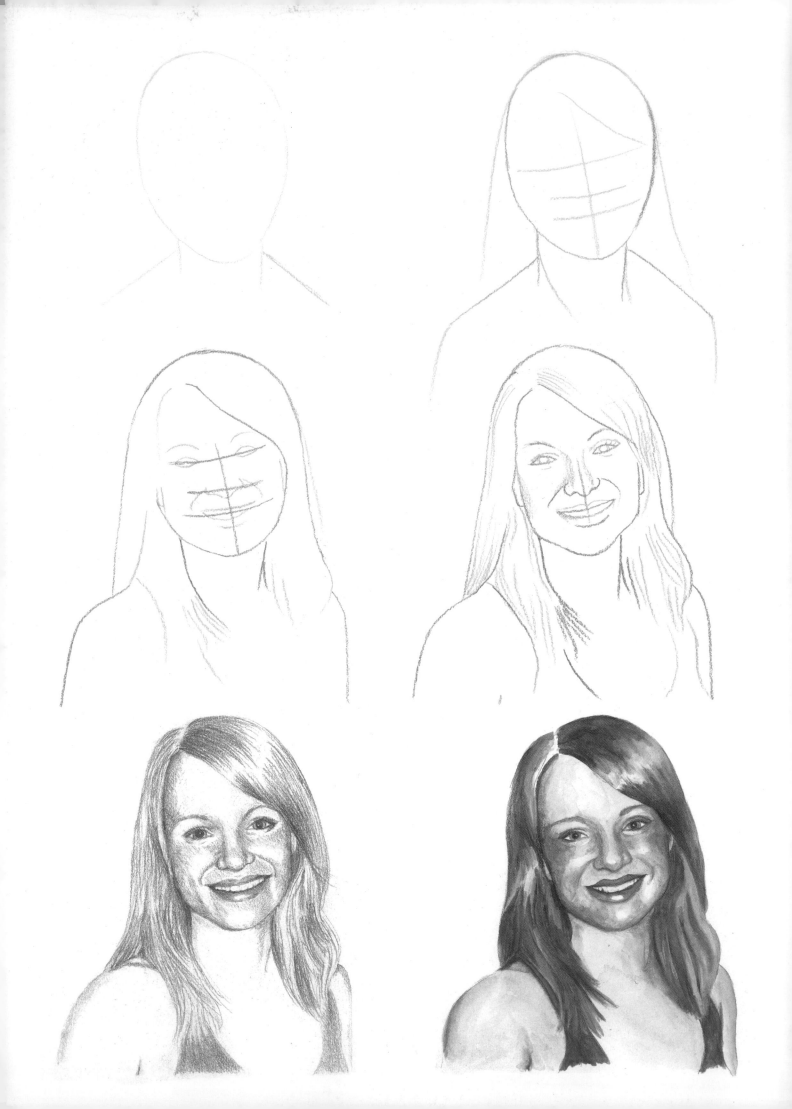